# SECRETS
*of*
# BEAUTY

# Secrets of Beauty

## Jean Cocteau

Foreword by Pierre Caizergues
Translated by Juliet Powys

**ERIS**

ERIS

86–90 Paul Street     265 Riverside Drive

London EC2A 4NE    New York 10025

ISBN 978-1-912475-55-1

Cover: Jean Cocteau, poss. *Orpheus*, pencil on paper.
Copyright © Designed by Alex Stavrakas

# Contents

# Foreword

Jean Cocteau was like one of those magicians who, having announced that they are going to reveal the secret of their trick, immediately perform another, even more amazing one. He offered up 'Secrets of Beauty' so frequently that the present volume could almost be called the 'New Secrets of Beauty'. It followed on from *Le Coq et l'arlequin* [*The Cock and the Harlequin*] in 1918, *Le Secret professionnel* [*Professional Secrets*] in 1922, *Le Mystère laïc* [*The Secular Mystery*] in 1928, and *Démarche d'un poète* [*A Poet's Process*] in 1954. In the same vein were the countless articles in which the poet promised to reveal secrets about his plays or films. In 1950, for example, he announced to the readers of *Lettres françaises* that he was going to disclose the 'trade secrets' of his film *Orphée*. This practice confirms Paul Valéry's famous dictum that every writer worthy of the name "carries a critic within himself and involves him closely in his work". And it was most often in the form of short texts—brief notes, pithy formulas—that Cocteau proposed to divulge his secrets. The reason this approach suited him so well was that it was unconstrained by traditional writing methods. Cocteau confided that he wrote on anything he could get his hands on, wherever he could. Édouard Dermit informs us that he often saw him writing next to him in the car, or while lying down, or when at the table (between fruit and dessert courses), using the smallest piece of paper or cloth. Cocteau said of the *Secrets*

7

*of Beauty* published here that they were "notes taken during a car breakdown on the road to Orléans". We should add the following details.

On 22 March 1945, Cocteau went to meet Jean Marais in Graçay, near Châteauroux, where the Leclerc division was stationed. He spent two days with him at Léon Pierre-Quint's house in Anjouin. He wrote to Marais that the journey back to Paris was complicated "by the American oil, which doesn't mix with ours". He continued: "A barrel-maker miraculously passed by and towed us to Lamotte-Beuvron. We spent the night there in a strange hotel and set off again the next day, at 7 a.m., and were towed to Orléans, where we left the car and took the train". This letter makes it possible to date these *Secrets of Beauty* and to shed some light on the following passage in the text: "Why do these thoughts come to me, to someone who is so reluctant to write? It's probably because—having broken down in a street in Orléans—I am writing them on the move, in a third-class carriage that keeps jogging me. I reconnect with this dear work [of writing] on the endpapers of books, on the backs of envelopes, on tablecloths: a marvellous discomfort that stimulates the mind".

To give a more accurate account of the genesis of this series of notes, we should recall that, although they give the impression of being a spontaneous outpouring, the poet did not allow them to be published without his having made a

few corrections. We know of two versions of these *Secrets of Beauty*, and together they show that the text was altered between its first publication in issue No. 42 of the journal *Fontaine* (May 1945) and its inclusion in the tenth volume of Jean Cocteau's *Œuvres completes* (published by Marguerat in 1950), where it appeared in the "Coupures de presse" [Press Clippings] section.

So why publish and republish these *Secrets of Beauty*, which avowedly promise new revelations from a poet who defined himself as "a lie that always tells the truth"? Because, although we come across therein expressions that he had used before (like the one we just quoted), many of them were renewed and updated. The author of *Sang d'un poète* [*The Blood of a Poet*], *Opium*, and *Léone* was influenced by Surrealism in spite of himself, and it's hard to avoid spotting mocking allusions to that movement in such statements as "all beautiful writing is automatic". The Resistance also left its mark: "Through whom did the Resistance of 1944 express itself? Through poets". And to those who accused him of repeating himself, Cocteau replied: "I will repeat myself until I die, and after I die"!

Cocteau first gave the title "Secrets de beauté" to an article published in *Comœdia* in 1943. It was a text devoted entirely to cinema, which was presented as the "poets' weapon". The version published in *Fontaine* did not dismiss cinema—a dozen of the notes are devoted

to it—but it placed "cinematic poetry" (that of Chaplin and others) alongside the poetry of the novel (that of Radiguet in particular), the musical poetry of Debussy, Stravinsky, and Satie, the graphic poetry of Picasso and Bérard, and, above all, the poetry of poetry (magnificently illustrated by Baudelaire, Rimbaud, Éluard, Hugo, Apollinaire—who is quoted with admiration several times—and Limbour, whose poem "Motifs" in *Soleils bas* was considered by Cocteau to be one of the most beautiful in the French language; he thought it equal in perfection to Apollinaire's "Colchiques"). In addition to the aforementioned names, these *Secrets of Beauty* contain all the figures of Cocteau's personal pantheon. In particular, we should add to the list of poets, painters, and musicians, Jacques Maritain on the subject of angels, and Joan of Arc, whom Cocteau mentions twice in his answers to Marcel Proust's questionnaire—as his "favourite historical figure" and his "heroine in History". A few light scratches are aimed (without going as far as drawing blood) at Maurice Barrès, Musset, Goethe, and Anna de Noailles. But the tone is never really polemical. The essence lies elsewhere: in Cocteau's renewed confessions concerning the solitude of poets and poetry, and in the awkwardness or lameness that alone favours the blossoming of beauty. We are reminded of the following lines from his book about Jean Marais, which are also present in these *Secrets of Beauty*: "Beauty hates ideas. It

is sufficient to itself. A work of art is beautiful just as a person is beautiful. The beauty I speak of provokes an erection in the soul. One cannot argue with an erection". Is it therefore pointless to attempt to get to the bottom of Jean Cocteau's *Secrets of Beauty?* We will content ourselves with relating them to an answer once given by the Dalai Lama, which Cocteau quoted on several occasions: "The secret of Tibet is that there is no secret. But it is the one that must be defended with the greatest care". This no doubt explains why Cocteau was intent throughout his career on putting his secrets into words. Secrets that would not be secrets if the poet kept them to himself. In *Le Rappel à l'ordre,* he confided that "a secret is always in the shape of an ear".

Pierre Caizergues

## Secrets of Beauty

*Too often we mistake for poetry a kind of rhythmic prose that has been contrived in the form of a poem. These false poems always appeal to audiences.*

*A poem is made of such subtle balances and disruptions—of such a stiff, light gait—that inattentive and disordered minds cannot tell the difference.*

✱

*A poem is not written in the poet's native language. Poetry is a language of its own, and cannot be translated into any other language—not even into the one in which it has ostensibly been written.*

✱

*The great loneliness of a poem is to be at once the height of autocracy and the height of anarchy. The great loneliness of the poet is to be completely invisible and visible in the extreme (a jester).*

✱

*No matter how pleasant it may seem, a poet's life is an atrocious thing. It's beset with inescapable torments.*

✱

*Poetry can only act as a physical charm. It's made up of a host of details that cannot be distinguished instantly. If this were not the case, then it would be impossible to expect anyone with concerns of their own to venture into the labyrinth of a style, to explore its every recess, and to lose themselves in it.*

*Poetry stops short of ideas. Ideas are lethal to it. Poetry is itself an idea; it cannot express ideas without becoming poetic and thereby annihilating itself.*

*This is what is poetic about a poet who makes an impression on his contemporaries. Poetry is concealed behind a mask. It's natural that subtle minds will scorn a great poet in his own lifetime, when they see only the dead matter that will one day disappear and liberate the poetry beneath.*

*Baudelaire: the damned women, the strange flowers, a carcass, etc. Hugo (we must always return to Gide's "Hugo, alas!"): the decorative flourishes within which we are likely to make the most astonishing discoveries.*

*I have just seen at Picasso's house a drawing on a large canvas that depicts a mass grave. It was as if the drawing was deepened by innumerable lines that the painter had previously erased. These lines bear witness to a search—not for a better line, but for the only line that will do.*

*One cannot, in consequence, detect a single syntactical defect anywhere on the surface of a Picasso canvas; he shows us a writing where a graphologist would be able to read the artist's soul like an open book. The entire canvas is intensely alive, and the smallest fragment of a line is alive with the same intensity as the whole. Everything is false, and everything is true. A hand, a shoulder, a mouth, a skull, a neck, an elbow, a breast, a knee, the toes—all are expressed in such a way that they take on the grandeur of a coat of arms. They recount the painter's nobility, and the deeds that ennoble him.*

*It is contrary to my method to shout to Picasso: "Stop! You can go no further".*

*He will go further. He will finish. He will paint. But perhaps by finishing and by painting he will build up those secretive ramparts of which I spoke—those defences which conceal poetry behind masks that satisfy an audience's thirst for prose and for decorative ornamentation.*

*A poet's disorder becomes a form of order that is rejected by convention. A poet will always react badly to being put on trial. If he responded well by the lights of the Church, he would be betraying God.*

*Poets are clumsy. They are skilful only in their clumsiness. This singular skill leads to their being accused of being skilful everywhere.*

*Poetry is always a scandal. It's a good thing we don't notice it. Alas, it only becomes visible a long time after the fact, when events imitate it, throwing the world into disarray.*

*Writers are always responsible, but not for that which they are charged with. They are responsible for their accusers, who are unwittingly influenced by them.*

*It's tragic that politics always lags behind the revolutions of poetry. As a result, poets who get involved in politics find themselves led astray in what is moribund in comparison to the era in which they really live. They risk being dragged down into death.*

16

*A poet is always under an occupation which he resists. This clandestine resistance is the basis of his work. The Resistance of '44 was only one visible image of this perpetual undertaking.*

*Heroism — the heroic act—is prolonged only by myth. Saying what we are going to do means no longer doing it. Saying what we have done means no longer having done it.*

*Sometimes the intuition that takes the place of intelligence in a poet assumes the form of intelligence, and makes him seem intelligent. This false intelligence will discredit him in the eyes of those who deny intelligence to the poet, protecting him from immediate success, which would be a kind of death.*

*Poetry is not holy just because it speaks of things that are holy. Poetry is not beautiful just because it speaks of things that are beautiful. If we are asked why it is beautiful and holy, we must answer as Joan of Arc did when she had been interrogated for too long:*

*"Next question".*

*To read poetry you must be inspired.*

*

*The word 'poetry' is much abused; it is used for everything that seems poetic. But poetry cannot be poetic. Poetic things acquire a borrowed radiance from poetry.*

*

*A poet's violence cannot be long-lived. Joan of Arc wasn't around for long.*

*

*The poet is a servant of forces that he does not understand. He must keep the house clean. His progress can only be moral.*

*

*A poet cannot achieve visible success. That which is clandestine cannot become official without ceasing to be clandestine. Those who believe that they are bringing a secret to light are mistaken. They are driven out of the shadows where poets live, and a new clandestinity re-forms behind them.*

*

*Every poet is posthumous. That is why it is so hard for him to live. His work hates him, eats him up, wants to get rid of him and to live on its own as it pleases. His voices leave him if he takes centre stage.*

*

*A poet is sometimes tempted to act alone and to enjoy the benefits that his curse brings. He cheats. He writes without help. Sometimes his voices forgive him; sometimes they leave him.*

*

*The trial of poets is inevitable. They can avoid it only by recanting. They should not be blamed for their doubts and their weakness: the examples of Christ and Joan of Arc would be sufficient to absolve them on this account. But they must endure rejection to the bitter end.*

*

*It is only by dying unjustly that one can hope to be reborn.*

*

*In all my life, I have only written one poem where luck did not desert me: "The Angel Heurtebise".*

*If luck deserts you, you have to win it back, struggle, start over. It is the moments when luck leaves us that please people and that allow poems to take root in people's memories. One day these passages fall out of favour, and luck appears.*

*Baudelaire's contemporaries saw only grimaces in his work, and only grimaces they admired. From behind these grimaces, the gaze travelled slowly towards us, like starlight.*

*Slackness, lyricism, and words are the downfall of young poets. I advise them to follow an old wives' regimen, a very simple form of hygiene: write backwards, join up your letters, write while looking at the paper in the mirror, make a geometric drawing, place words on the points where the lines intersect and fill in the gaps afterwards, turn a famous text upside down by inverting the meaning, and so on.*

*In this way they will become athletes and build their mental muscles. Strong goodness is stronger than wickedness that passes for strength. One must overcome conformity to the latter. One must be good.*

*The left cannot go right. If it seems to be going right, that is because it has become right; it is no longer left. It will never be left again. That's the end of it.*

✳

*Poetry is subject to specific laws. A serious man who is capable of feeling like a poet can give the impression of being one simply by knowing these laws and by studying the mechanisms that produce beautiful or unusual things.*

✳

*Beauty is lame. Poetry is lame. It is from a struggle with the angel that the poet emerges—limping. This limp is what gives the poet his charm.*

✳

*If poetry didn't limp it would run, and it cannot run because it counts its steps and moves erratically.*

*A poem stands in defiance of what man habitually considers to be the best way of expressing his thoughts. One must therefore be very humble in order to read a poem without antagonising it.*

✳

*No one is more humble than a poet, who is nothing more than a vehicle. What gives him an air of pride is the fact that he is the defender of the force that inhabits him, as Joan of Arc defended the cause of God.*

*In a fine article, Paul Claudel said that man is entitled not only to justice, but also to injustice. The poet's long efforts are rewarded by the smallest twist of fate.*

*The masses can love a poet only by misunderstanding him.*

*Poetry is the only commodity that does not depreciate. It is the only food that man really needs.*

*Radiguet noted that all publishers have owed their fortunes to a poet.*

*Cinematic poetry: I am often asked what I think of it. I think nothing of it. I don't know what it is. I have seen films made without the slightest poetic concern that nonetheless exude poetry, and I have seen poetic films in which the poetry simply doesn't work.*

*Poetry in films derives from unusual relationships between objects and images. A simple photograph can produce these relationships. I have photographs at home that were taken in the warehouse where the Germans melted down and destroyed our statues. The most mediocre statues became great.*

*Poetry works like lightning. Lightning strips a shepherd bare and carries his clothes several miles away. It imprints on a ploughman's shoulder the photograph of a young girl. It can obliterate a wall and leave a tulle curtain untouched. In short, it creates unusual things. The poet's strikes are no more premeditated than lightning.*

*Poetry borrows astonishing contrasts that occur by chance. It disorientates; it accidentally establishes a new order.*

23

*The Surrealists might once have been my sole audience. When I fell out with them, I no longer had an audience. But my role was to love them and to follow them in spite of their attacks. Our dramas were dramas of love. To see anything sordid in that would be a huge mistake.*

*These days my best friends are Surrealists. The politics of literature no longer come between us. All that remains is our memories of the war. We talk about them as little as possible, like genuine warriors. Our reasons for falling out would seem meaningless to anyone who tried to understand them. I was in fact the only enemy they could possibly have had, since one cannot choose an enemy from outside of one's family. They were a group; I was free. The only way I could, or should, ever have defended myself was through my work.*

*Nowadays I am constantly being referred to in articles as a Surrealist. They called* The Blood of a Poet *a Surrealist film. None of that matters any more.*

*I have never been able to obey any order that didn't come from inside of me. The most important thing is not to get lost in the embrace. Stay sharp at all costs. Stay on point. Don't get soft.*

✱

*Poetry is a precision instrument. A precision shot. A long-range shot.*

*

*People say to me, "You don't change". I reply, "I'm too distracted".*

*

*A poet must concern himself with poetry alone.*

*

*Poets receive only love letters.*

*

*A man without a drop of passionate blood will never be a poet.*

*

*B... wrote poems before he was shot. A man who wants to outlive himself thinks only of writing poems.*

*

*Apollinaire spoke to me about 'event poems': each poem must be an event. Sometimes poets milk events for more than they are worth. These opportunistic poems are always the ones that attract the most attention.*

*The absence of rules in poetry forces the poet to discover methods that bestow upon his work the mystique of a secret cult ritual.*

✳

*Style is not a dance. It's a process.*

✳

*A poet should be recognisable not by his style but by the way in which he looks at things.*

✳

*If you inadvertently make a gesture of intelligence to the reader of a poem or the audience a play, they will notice it, and the rest will escape them.*

*I heard Charlie Chaplin complain that the only thing in* The Gold Rush *that anyone ever talked about was the bread roll dance. After* Orphée, *everybody congratulated me on an image that I had not been strong enough to cut.*

✳

*The vulgarity of images... People like and are reassured by worn-out ways of saying things. Hence the ubiquity of simile in poetry.*

*It is a privilege to be born a poet. Many writers of the encyclopaedic breed attack poets out of bitterness at not being poets themselves. They try to overcome their impediment and end up producing hybrid works. A whole generation of young people is thereby deceived.*

*

*Not having been born a poet made Barrès sick. I have sometimes been touched by this cripple who so wanted to get up from his armchair.*

*

*At first a poet is not read at all. Then he is read badly. Then he becomes a classic, and habit prevents him from being read. Eventually, he retains his few early lovers for eternity.*

*

*The glare of fame obliterates all depth. Works are flattened by it.*

*

*What matters in poetry is neither what is said, nor how it is said, nor the meaning, nor the music. What matters is something else, which cannot be analysed.*

*

*A poet should possess both the chivalry and the memory of kings.*

*A poet must not refuse honours, but he must see to it that no one thinks of offering them to him. If they are offered to him, it is because he has done something wrong. He must then accept what he is offered as a punishment. If he refuses the honours that are offered to him, he is deluding himself and others: his work must have accepted them in some way, and it must be his work that refuses them. He will therefore look for the ways in which his work accepts them (of these he is probably already aware) and he will fortify himself against his weaknesses.*

*Chances are he is guilty of having undertaken a work without receiving an internal commandment to do so, and that this work has disclosed to the Prince something that ought for the time being to have remained invisible.*

*This is what Erik Satie meant when he said: "It is not enough to refuse the Legion of Honour; you have not to deserve it".*

*Honours are admissible for the poet only if they are addressed—regardless of his feelings on the matter— to his person and to the air of responsibility that his career has earned him.*

*"One must not be recognised for what one does" said Max Jacob, who himself exemplified this saying. "Honour Max Jacob" said X or Z to a minister, who honoured him without ever having read him.*

*The Popes and Louis XIV regarded Michelunge-lo, Racine, and Molière as workers on their payroll. They were interested in what was showy in their work, not in what was invisible.*

*They would have been very surprised—angry, even—if they had guessed that the glory of these artists would eclipse their own, and that their work would prove more consequential than their reigns.*

*✷*

*Young people are not mistaken. They love us for all the things in our work that go over the Prince's head. They fraternise with fellow youths who are also attached to our works (though our works are not ours alone).*

*✷*

*A poem arises from a marriage between the conscious and the unconscious; between will and a lack of will; between accuracy and vagueness.*

<div align="center">✷</div>

*All beautiful writing is automatic.*

<div align="center">✷</div>

*A poet must be a saint, a hero, but without anyone knowing it. He must have no fear of death, with which he ought to be on first-name terms.*

<div align="center">✷</div>

*A poet hates himself. He respects only the vehicle within himself.*

<div align="center">✷</div>

*A poet's laziness, waiting for voices: a dangerous attitude. It means that he isn't doing what he needs to do in order to make the voices speak to him.*

*Discover physical and moral hygiene. Always be in a state of grace. The poet's religious exercises.*

*To sleep is to return to the stable. Don't sleep too much.*

*

The Blood of a Poet *has been the subject of a thousand interpretations. A whole generation of young people has recently interpreted it as the Passion of Christ. What can I do? These young people translate the film the way we try to translate nature. This poem in images was made in half-sunlight. All I was trying to do was to interweave themes that moved me and to intrude as little as possible on this unreal documentary sequence. There was never a symbol. That's what makes it possible for people to symbolise. I am a cabinetmaker. I build a table, and it's up to you to make it turn around and talk.*

The Blood of a Poet *is a film that 'doesn't work out'.*

*The poet is the enigma. He doesn't pose enigmas. He tells of a world that he inhabits—a virgin world that tourists can neither get to nor litter with their greasy papers.*

*The public has its poets. My film is addressed to them. They intuit that our world exists, and they do their research. This Tibet is within us and all around us. It is our birth, our sleep, our youth, our love, our blood. But the inflexible everyday world we also live in instils in us an ignoble fear of discomfort.*

*

*It is when poets break with cowardly comfort that viewers perceive flashes of poetry in a war film upon which current events have imposed monstrous distortions, forcibly removing its spectators from the state of receptiveness in which they expected to live and die.*

<p style="text-align:center">✶</p>

*A poem is a series of accidents liable to cause discomfort.*

<p style="text-align:center">✶</p>

*On solitude: discomfort is the hallmark of the poet. His world is almost uninhabitable. People sense this. They enter it as little as possible, as quickly as possible, and only out of curiosity.*

<p style="text-align:center">✶</p>

*I used to use a detective agency's advertisement to describe the figure of the poet: "Sees everything, hears everything, nobody suspects a thing".*

<p style="text-align:center">✶</p>

*A poet never has enough freedom. Everything that he hoards turns against him. He is fortunate if somebody plunders him, dupes him, abandons him, ransacks his house, and drives him out of his home.*

*The poet is soothed by that which frightens others. Violence reassures and comforts him.*

*Formlessness is unbearable to the poet.*

*The poet has a truth of his own that people mistake for a lie. The poet is a lie that tells the truth.*

*Revolutionary souls—who should despise poetry more than anyone—always end up resorting to it.*

*Revolution always has an air of poetry because poetry is revolution.*

*Through whom did the Resistance of 1944 express itself? Through poets.*

*I wasn't joking when I wrote: "Victor Hugo was a madman who thought he was Victor Hugo". Hugo's greatness lay in the fact that he was mad and that nobody in the world suspected it. His general style would not have allowed him to write those works that so greatly surprise us had he not suffered from the organic disorder to which a thousand details of his intimate life attest. (Seen at Jean Hugo's home in Fourques: notebooks, drawings, and innumerable monograms in which the V and the H are combined with all the disquieting intensity of a maniac.)*

*Goethe is often ridiculous but with a sense of the ridiculous. Goethe is the opposite of Victor Hugo.*

*It was neither Rimbaud's "rampart overgrown with wallflowers" nor Baudelaire's "evenings in the woods with jugs of wine" that made them famous. Their fame comes from the exoticism seemingly contained by Rimbaud's "The Drunken Boat", and from the erotic exoticism behind which Baudelaire conceals his poetry.*

*The poet uses ornamentation to win people over and to seduce his readers. One day the ornamentation will fall away.*

✱

*There is nothing to discover in Musset. What he was, he remains. He deceives no one. He is reassuring. This is why there are so many statues of him in Paris.*

*The poet risks nothing by copying. He expresses himself to the extent that he is incapable of copying.* Radiguet told me before writing Count d'Orgel's Ball: "I'm going to copy La Princesse de Clèves". Apollinaire admitted to me that he was trying to write like Anatole France. Racine copied Euripides; Molière, Molina.

*When I wrote the poems for* Opéra *("Secret Museum") I thought I was copying the Civil Code; with* Thomas the Impostor *I thought I was copying* The Charterhouse of Parma.

*Apollinaire chanted his poems as he wrote them, and they enchant us. These old wives' secrets are better than Aristotle.*

✱

*For a poem, for a play, for a film, one must imitate the oyster and produce a kind of outgrowth that the pearl will then form itself around.*

✱

*A poem always unravels too quickly. You have to tie and retie it firmly.*

✱

*After a certain point one becomes incapable of making a meaningless sign.*

Genet said: *"Picasso's luck is that he is always with Picasso"*.

*The fairground people: Bérard put on a sumptuous show with a few strips of clothing, four poles, and four old canvases. Everything in the theatre and the cinema is far too plush and expensive.*

*The Bath of the Graces in Picasso's* Mercure *was a sumptuous show. There was just an Andrinople curtain, a fake marble coping, a tilted surface pierced with holes, and, emerging from these holes, grizzled stagehands painting old wigs and wearing pink swimming costumes that were stuffed with enormous fabric breasts. Such is the theatre.*

*Some languages are poetic and yet unsuitable for poetry. French is a suitable language for poetry because it is precise and does not sing. It is a piano without pedals, like Gide said. It is only by combining harshness, sharpness, and dryness that we can achieve a rhythm that ends up having nothing to do with the words we're using or the things we're expressing.*

*Poets should fear adjectives like the plague.*

*That decisive way of saying things in French that no French intelligence is struck by—with the exception of a certain intelligence of the heart.*

*

*Seriousness that imposes: Never believe it. Never confuse it with gravity.*

*

*The poetic allure is the element through which the poem retains its colour, its freshness, its life. It is in this element that the poem can really breathe, like a sea plant. The poem is a thinking jewel.*

*

*Pierre Reverdy said: "There is no such thing as love. There are only proofs of love". I would add: "There is no such thing as poetry. There are only proofs of poetry".*

*

*Almost all children have a poetic genius that quickly spoils. Their inexperience causes them to postulate spurious connections between things, thereby producing flashes of poetry.*

*

*Childhood: Protecting and preserving childhood is the poet's great concern. Youth is nothing. Youth is the age at which everybody—and, therefore, nobody—is a poet. Rimbaud was never young. He was a child and a man. Radiguet died an old man at the age of twenty. His death was that of a child.*

✶

*Silence is the basis of the poem. Poetry is the way in which silence is thwarted, insulted, duped, tormented, struck at, wounded, defeated.*

*There are moments when silence is distracted. Too late! The poem is there.*

✶

*The poem as the blood of silence.*

✶

*The poem as the cry of silence.*

✶

*The poem as the written cry.*

✶

*The canvas hates to be painted. The colours hate serving the painter, the paper hates the poem, and the ink hates us. What remains of these struggles is a battlefield, a famous date, a hero's testimony.*

<p align="center">✱</p>

*A masterpiece is a battle won against death.*

<p align="center">✱</p>

*It is not by writing the word 'table' that one talks about a table. It is not by writing the word 'tree' that one talks about a tree; it is not by writing the word 'love' that one talks about love.*

<p align="center">✱</p>

*Pushkin is a good example of the inimitable rhythm of poets. Nothing remains of him in translation. But his charm (in the truest sense of the word) works on Russians, whoever they may be. It can't be about the musicality of his language, because in that case he would go out of fashion. It can't be about the meaning, because, when translated, that meaning turns out to be mediocre. It can only be a question of an internal rhythm that Pushkin perhaps owed to a drop of black blood.*

<p align="center">✱</p>

*Éluard's clear water reflected the nature of his soul and so lovingly deformed it. Those who imitate him can only reflect a reflection.*

✳

*I find it increasingly difficult to get in touch with the realism of life. Especially in the morning, when I leave behind a dream life that has nothing to do with my own. This is why I like film work, the overwhelming responsibilities of which force me to stay in the present. It is also no doubt why a fairly simple film like* The Eternal Return *has proved so inspiring to countless anonymous persons who eat themselves up in rural solitude writing letters.*

*This lack of realism makes it very difficult—almost impossible—to write the memoirs I am constantly being asked to write. These would be memoirs of a fairly extraordinary life, but one less extraordinary than that of my dreams, which I force myself to forget immediately. The life of dreams would otherwise disrupt my constant effort to cling to life—an effort that makes me seem active and sociable.*

*Poetry is ill-served by people who live with their feet on the ground while wanting to look like dreamers. Poetry walks with one foot in life and one foot in death. That's why I call it lame, and it is by its lameness that I recognise it.*

*The trial of Joan of Arc was the trial of a Resistance leader by collaborators. I'm surprised that there has been so little emphasis on what a great writer Joan of Arc was. Every word she uttered was perfectly placed. No other words would have sufficed. She said exactly what she wanted to say. Poetry was within her, and it expressed itself.*

*The poet's intelligence is nothing more than intuition. Bergson more than anyone had an 'intuition' of an outside—an intuition that the poet's universe is not our own.*

*I have noticed that one must write countless pages before a single word strikes a chord with a reader, or a single detail is remembered. The truth is that people will pass judgement on our house on as slight a basis as the catch on the door. This observation gives me a sense of vertigo that makes me lazy.*

*I cannot go on without saying that Georges Limbour's poem "Motifs" in* Soleils bas *is one of the most beautiful poems in the French language. Equal in perfection to Apollinaire's "Colchiques".*

*Max Jacob sought to subdue silence. He was capable of saying anything for the sake of keeping silence quiet. In the same way, I have seen the Countess de Noailles gesticulate while drinking at table so as to avoid being interrupted.*

<div align="center">✴</div>

*Why do these thoughts come to me, to someone who is so reluctant to write? It's probably because—having broken down in a street in Orléans—I am writing them on the move, in a third-class carriage that keeps jogging me. I reconnect with this dear work [of writing] on the endpapers of books, on the backs of envelopes, on tablecloths: a marvellous discomfort that stimulates the mind.*

*A room paralyses me; a desk is the death of me. How many books have I composed in my head at times when I had no way of transcribing them? If I'd tried to write them down afterwards they would have evaporated like dreams, leaving only vague outlines and the empty façades of the main square in Orléans.*

<div align="center">✴</div>

*Letter from J. F. L. P., written from Antibes. He told me that he had gone to Villefranche on a pilgrimage. When he arrived he was delighted to find Villefranche intact, with the Welcome Hotel still in its place. He rushed there. He entered. But, alas! All that remains of the Welcome Hotel are the façades; the interior no longer exists.*

*Perhaps it's a good thing that this magical place of discovery and encounters—those rooms to which some came to invent myths and others to visit those who were inventing them—has become a myth in its own right, that it exists only in memory. It was there that I wrote* Orphée, Opéra, *the* Lettre à Maritain, *and, with Stravinsky,* Œdipus Rex. *It was there that I drew the portrait of* L'Oiseleur *and made the poetic objects that the Quatre Chemins exhibited in 1926.*

*The Welcome Hotel, with its façades painted in Italian trompe-l'œil, was our Boulevard of Crime: a hall of mirrors, a palace of mirages, a barracks for ghosts, an opera box, the backstage of dreams, and our rendezvous with the angels.*

*It lived on all that, and then it died from it.*

*

*We abused the angels. As Maritain said, we got through them at an incredible rate.*

*Nowadays all the titles of plays and films you see on posters are about angels. We must bid them farewell.*

*These robust, powerfully-winged young characters appealed to us because of their mystery and their insolence. We placed them outside of all morality and quickly got into the habit of considering them as cruel animals, as the shock troops of discomfort and insurrection.*

*It was only a small step for us to imagine that the angels were literally living inside Vauban's fortifications, from which they might have taken flight in order to shake up the visible world and simplify it for us.*

*We did not consider for a moment that they might understand the wretched laws that we live by. We never discussed it. We observed their disorders. They excused ours, and, like Jacob, we fought against them bravely. The results were death and crippling injuries. Such was the honour roll of our school.*

*

*Actor-poets: These are the rarest of all.*

*It is not through tone, expression, or gesture that the actor-poet proves himself, but through a certain motion of the soul that brings unexpected elements into play, and discomfits the mass of spectators.*

*Jean Marais's athletic physique protects him somewhat from the hatred of poets, and thus he deceives a great many people. Alain Cuny is less well-equipped to bring about such a misunderstanding. Charlie Chaplin was protected by laughter. When he made people laugh less, he frightened them. His early films are as terrible as Kafka.*

*Debussy's* Pelléas *is a poetic masterpiece. Maeterlinck's text is a masterpiece of poetry. The poetry of opera owes far more to the librettist than to the musician. But people don't realise this. They think that the poet is inferior to the music and that, when isolated from it, he is even a little silly and old-fashioned.*

*But it is precisely that which is displeasing about Maeterlinck that saves him, and the elite's too rapid and unanimous access to Debussy's music proves that that music is poetic prose layered over Maeterlinck's prose-poetry.*

*Picasso said: "Music is prose".*

*

*In a story by Madame d'Aulnoy, it is said: "The Prince had his portrait painted to send to the Princess, and the painter was so skilful that the portrait could pronounce a few words". One can imagine the Princess's excitement.*

*I have read hundreds of the letters that film actors receive. They are full of spelling mistakes (the same word is used every time: 'dédicasse'). These semi-literate letters fail to do justice to a certain passionate intelligence concerning what the sender has seen.*

*This world without spelling doesn't care who the film is by. All that matters are the actors, and the heroes whom they portray. This uncultivated world receives sensations that are all the more vivid because they are conveyed by speaking portraits that enable people to dream of the originals.*

*The hallmark of the poet is that he conceives of (in order to inhabit it) a universe in which time, space, and volume are organised differently from how they are in the human universe. The result is a kind of invisibility.*

*

*Childhood memory.*
*The flour gave us away. We hid in the mill and*
*came out black from head to foot.*

✱

*Memory of youth.*
*We locked ourselves in the coal mine. The coal gave*
*us away. We were white from head to foot.*

✱

*Journey's end.*
*This is the crisp early morning, with its bells, its*
*roosters, its coughs, its growing beard. Now is the*
*time to cling to life and to believe in it. There's*
*so much to laugh about! The time has come*
*to live—a little.*

✱